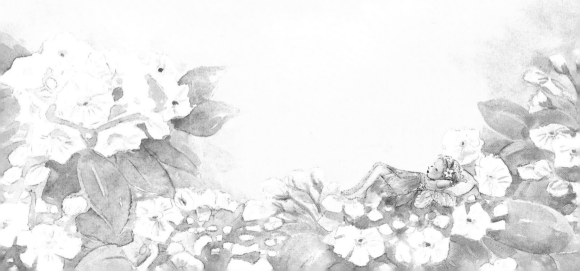

Fairy Kisses

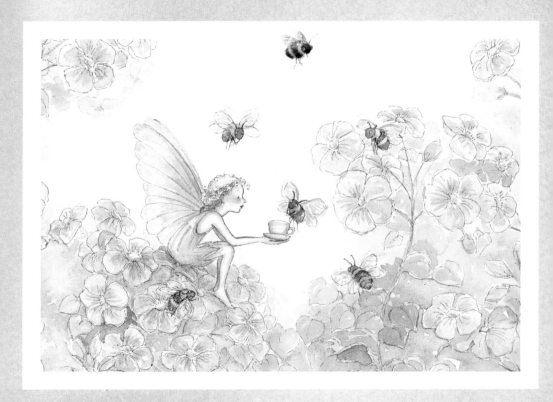

Fairy Kisses

Illustrated by Becky Kelly

Written by Patrick Regan

**Andrews McMeel
Publishing**

Kansas City

www.beckykelly.com

03 04 05 06 07 EPB 10 9 8 7 6 5 4 3 2 1

ISBN: 0-7407-3154-8

Illustrations by Becky Kelly
Design by Stephanie R. Farley
Edited by Jean Lowe
Production by Elizabeth Nuelle

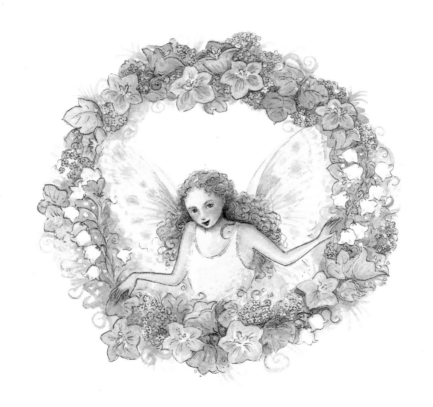

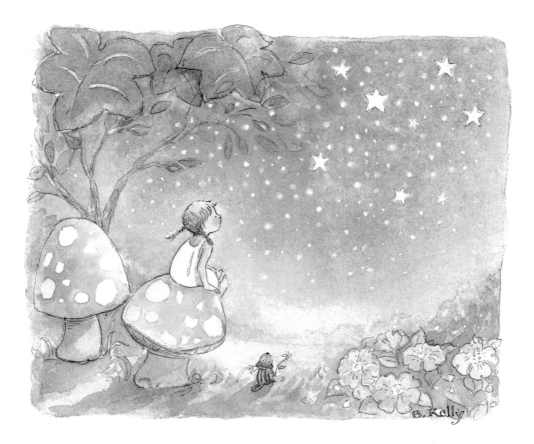

Why do we find it so hard to believe
In things we cannot see?

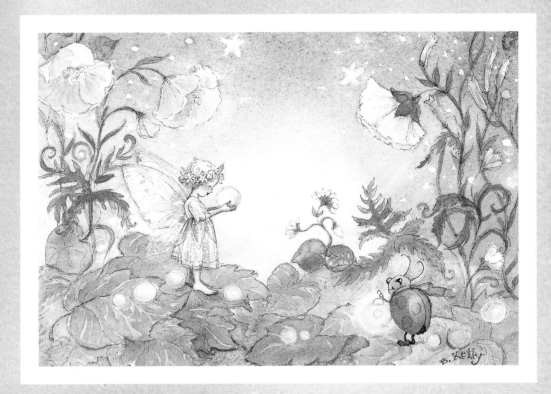

Perhaps it's that we've grown too old
To welcome mystery.

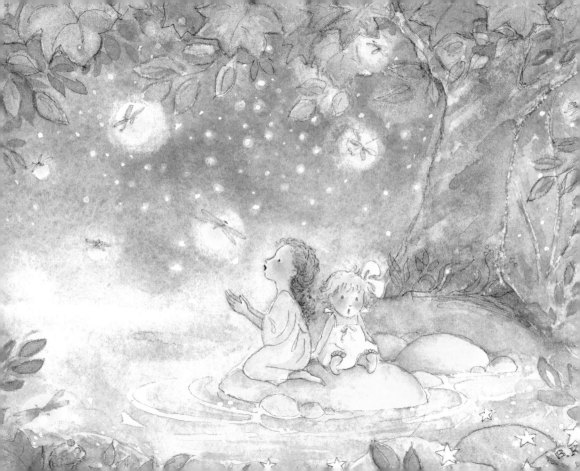

We've grown to trust our eyes too well
And forgotten what's behind–

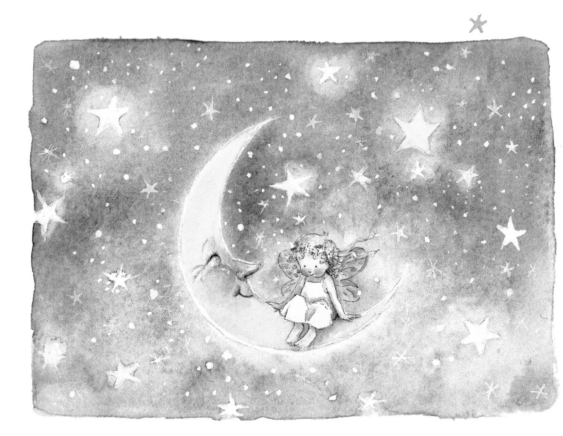

The land of faith and fairy-tales
borne in the sweet child-mind.

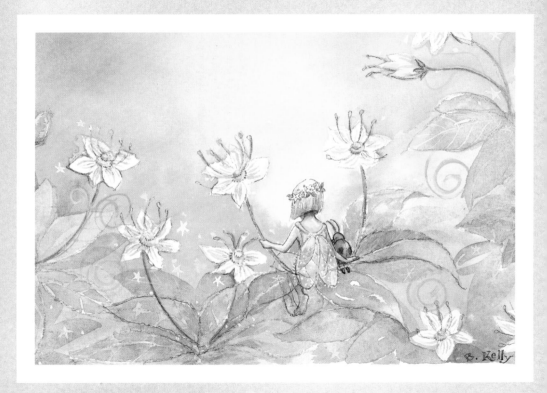

B. Kelly

But fairies haven't fled, my dear—
They've been here all the while,

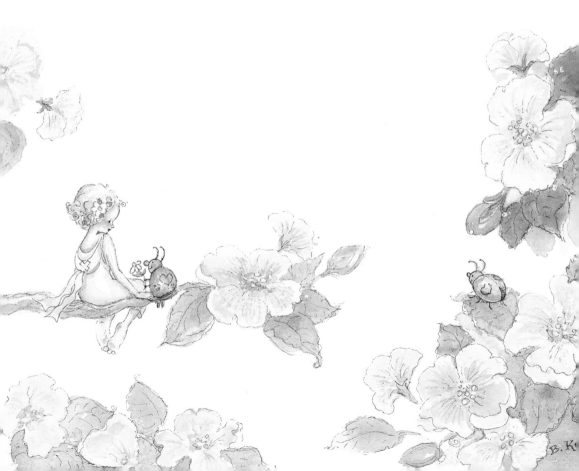

Hiding closer than you think
And watching with a smile.

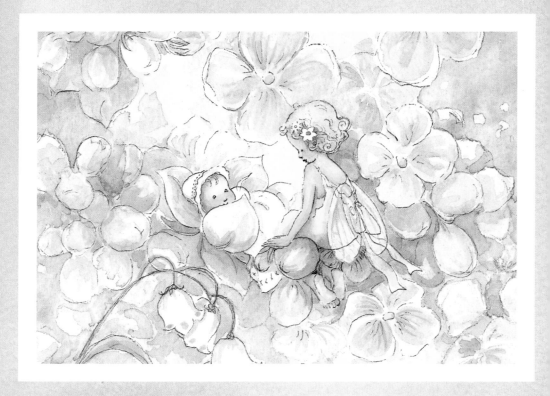

A fairy's breath still brings to us
A blossom's sweet perfume;

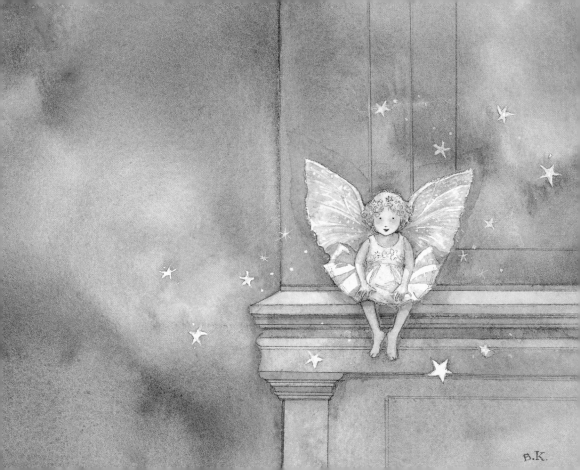

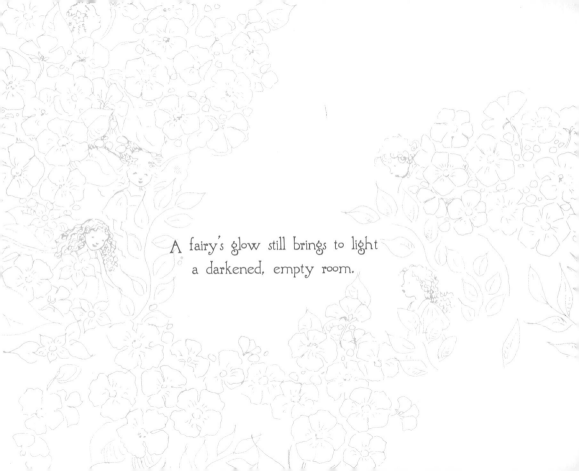

A fairy's glow still brings to light
a darkened, empty room.

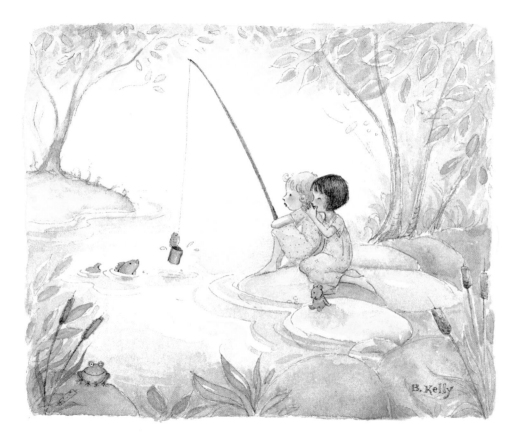

And what about that sense of calm
That visits from the blue—

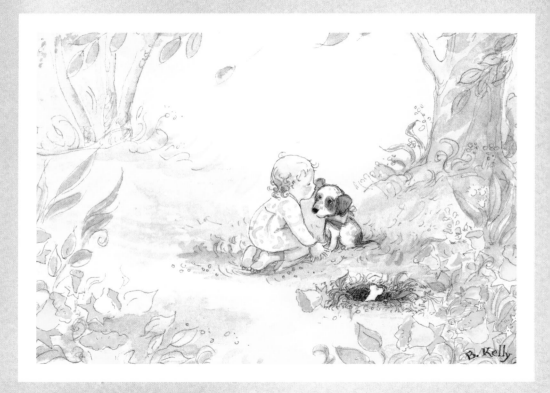

The sudden feeling we are loved
That fills our hearts anew~

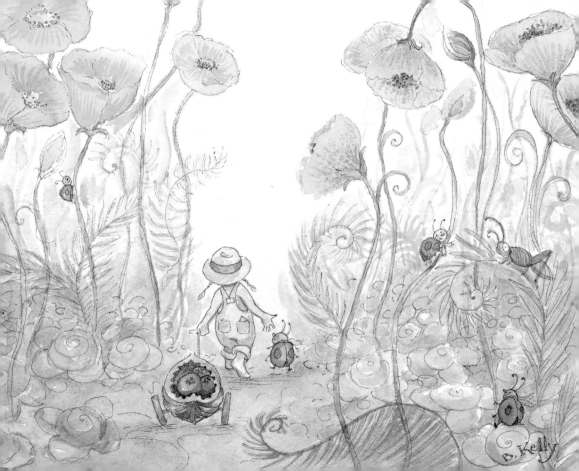

What of the out-of-nowhere tune
That springs our step along?

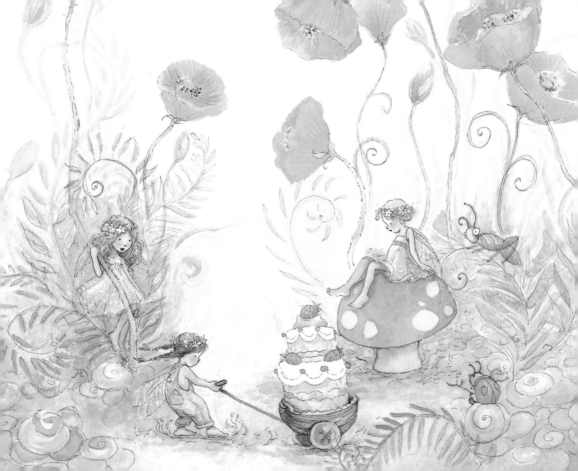

These are the fairy kisses, dear—
Those are the fairy songs.

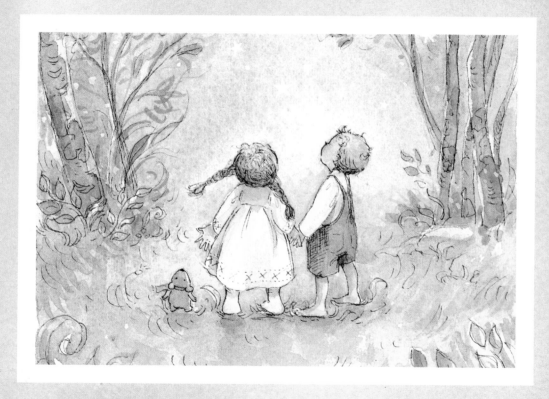

So listen closely as you walk
Through woods on autumn's eve-

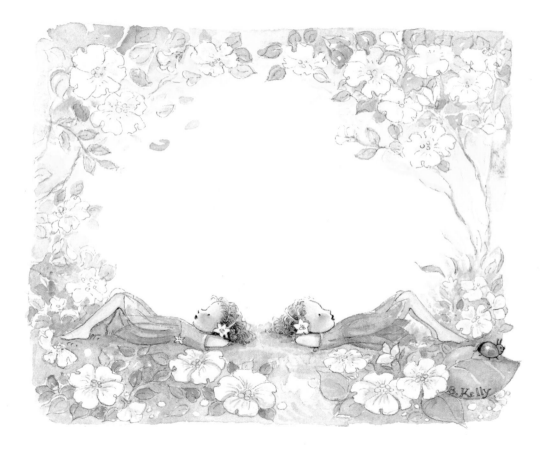

And pay no heed to those who say
that dreamers are naïve—

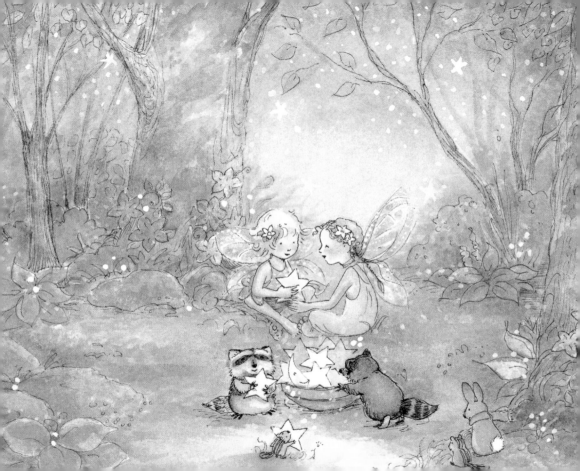

For fairies dwell among us still,
Though seldom in our sight.

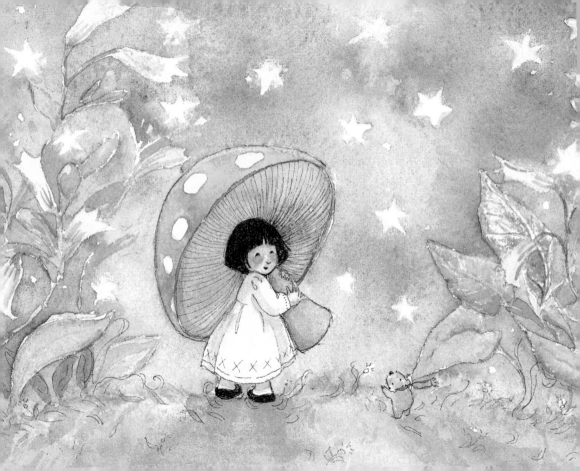

They paint the grass with morning dew
And light the stars at night.

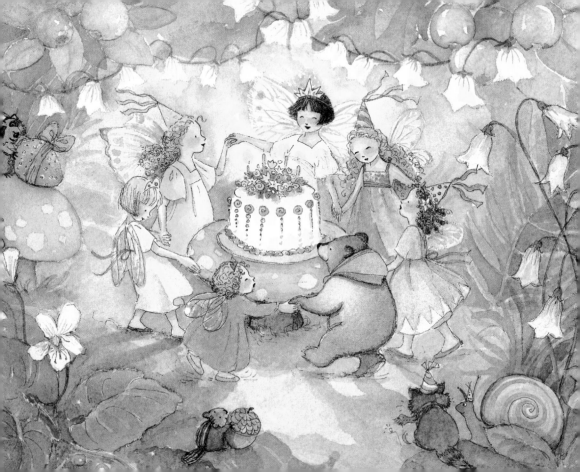

The fairy world still hums with life,
But only faith can free it.

So believe in what you cannot see—
And maybe then you'll see it.